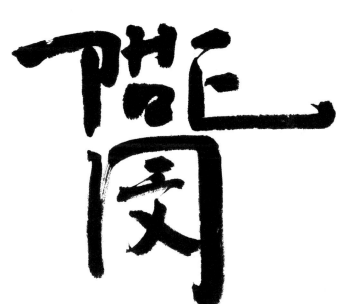

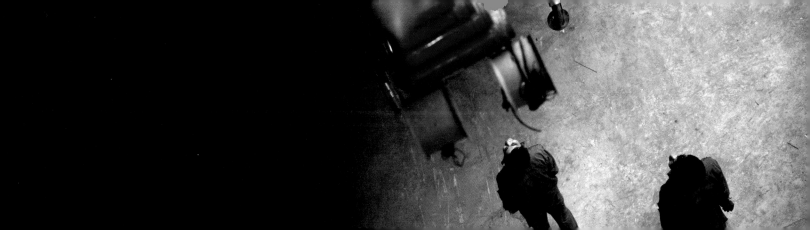

PH凤OE凰NIX

A poem by Ouyang Jianghe
Inspired by Xu Bing
Translated by Austin Woerner

欧阳江河诗歌创作
与徐冰艺术对话
Austin Woerner 译

mccmcreations

ZEPHYR

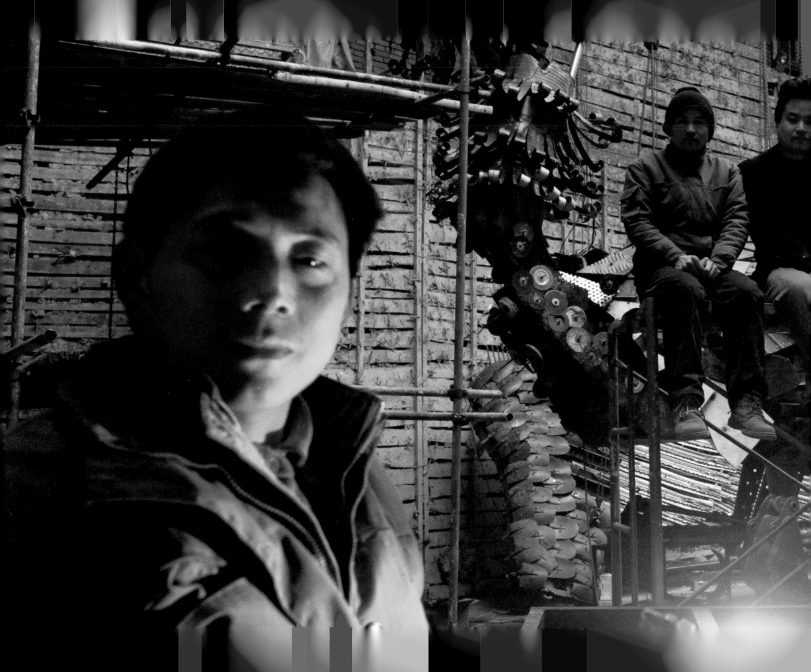

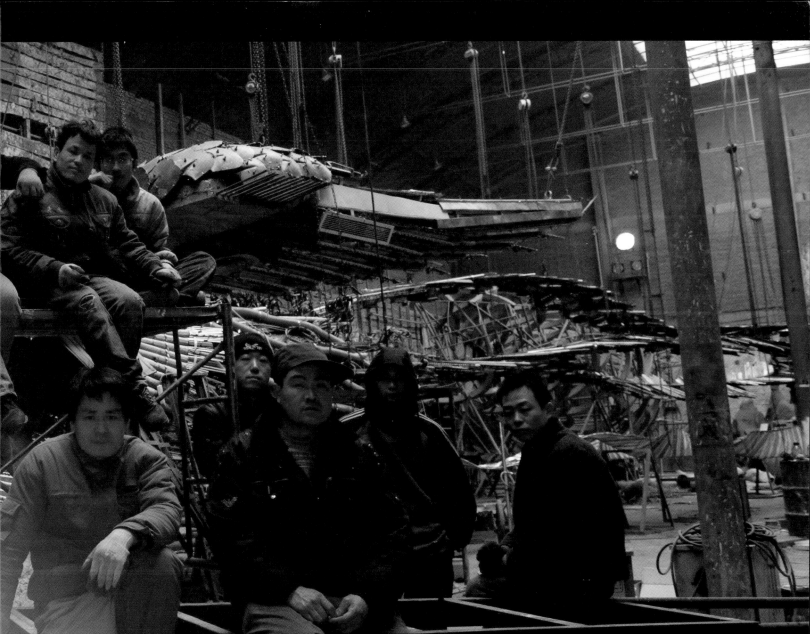

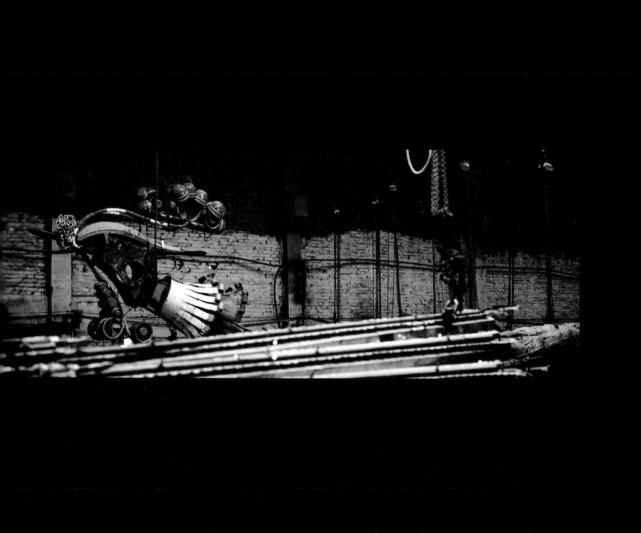

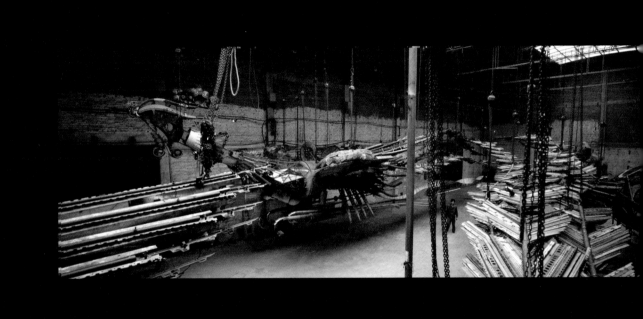

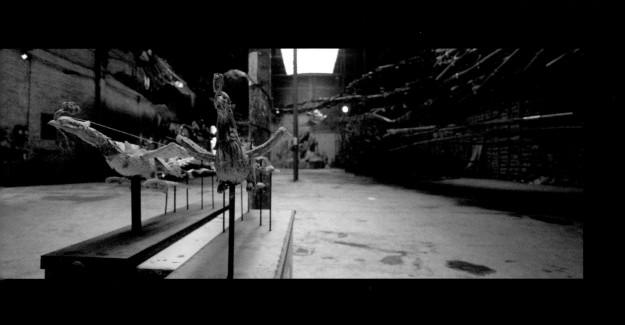

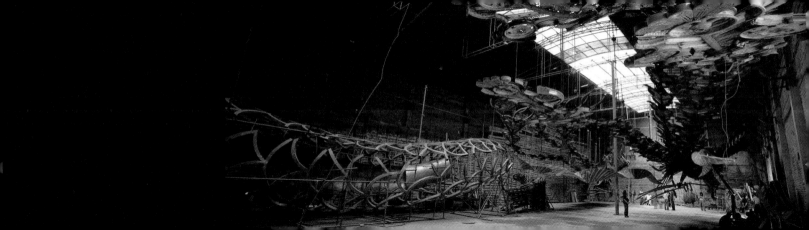

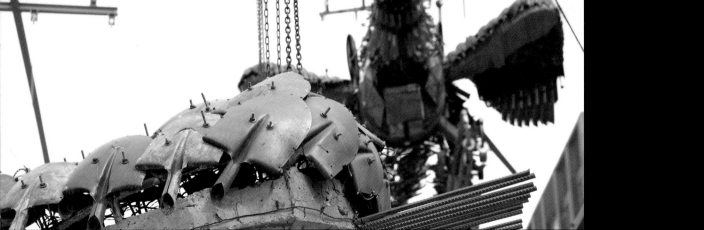

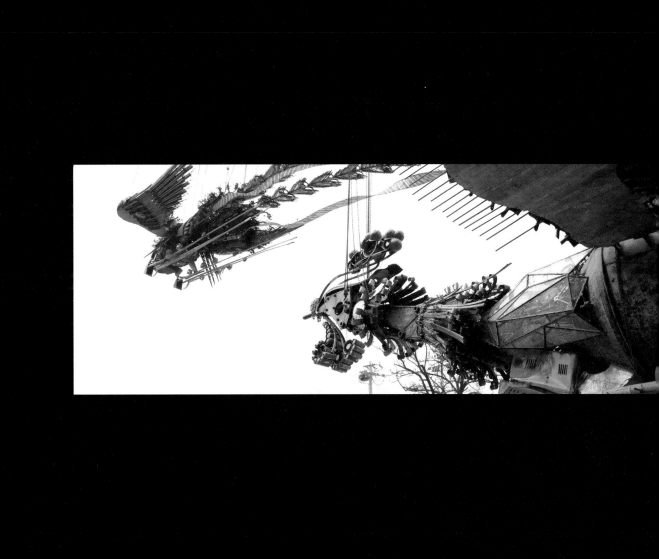

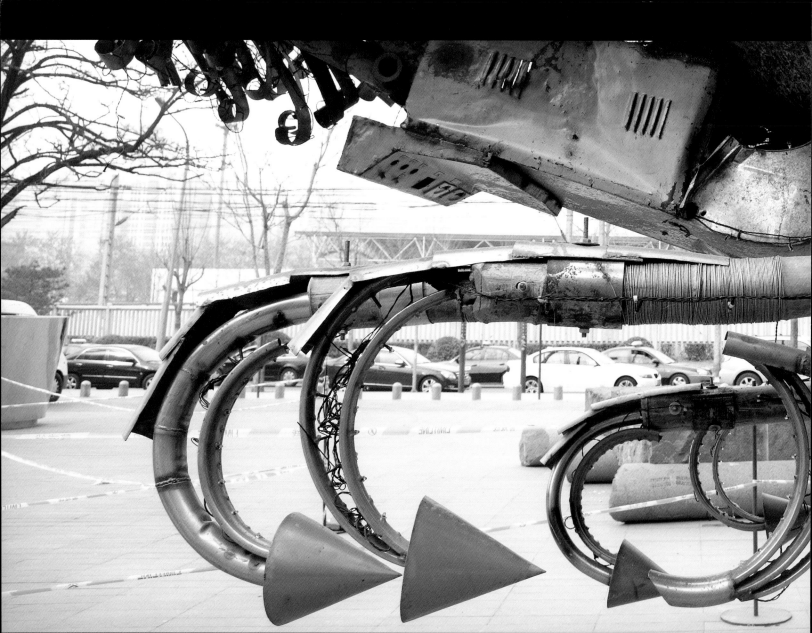

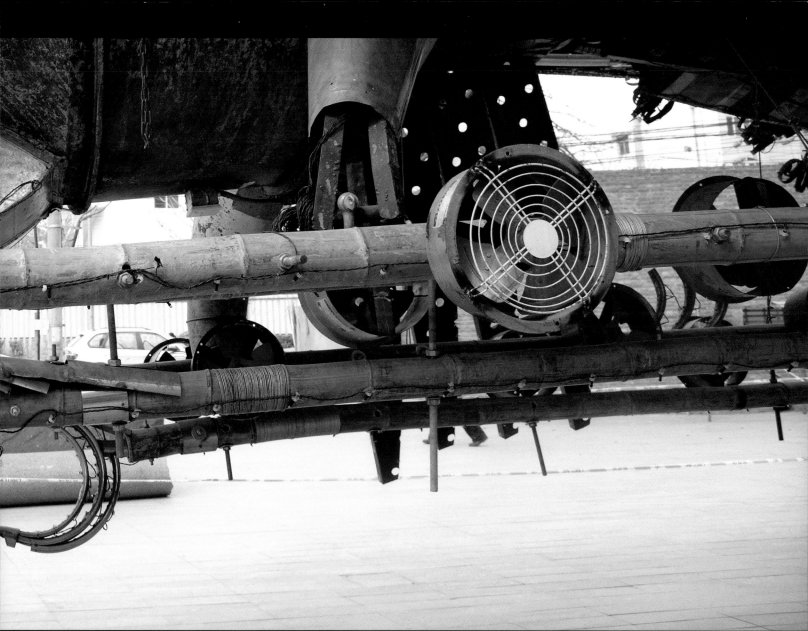

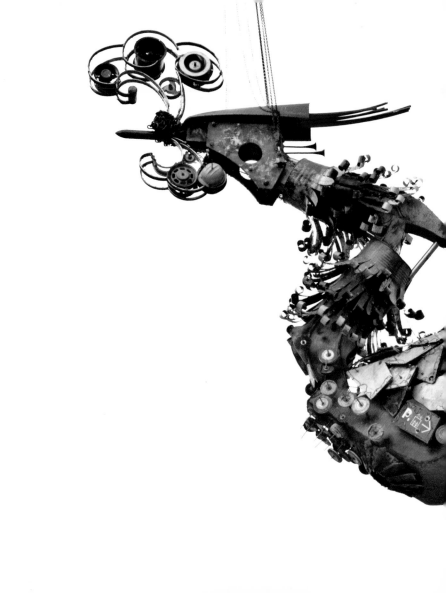

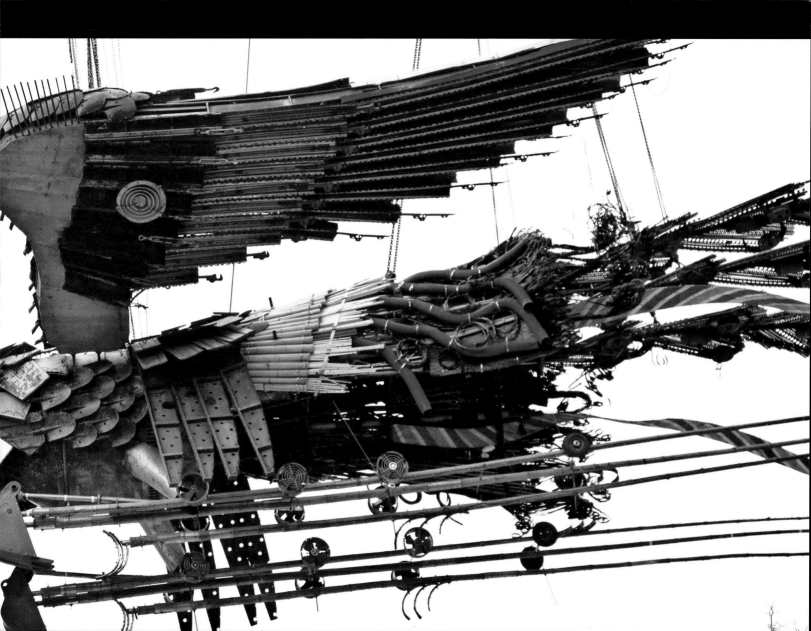

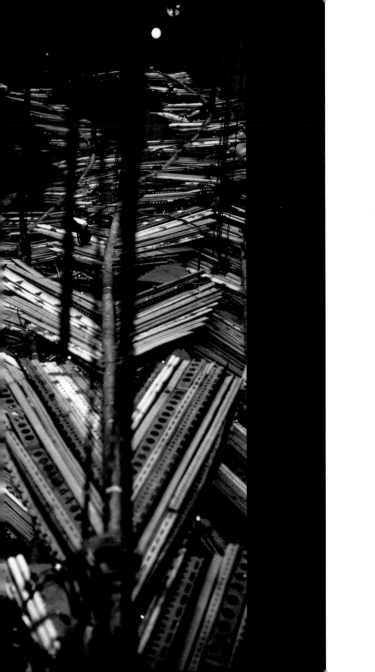

Translator's Preface
Austin Woerner

Ouyang Jianghe belongs to the generation of Chinese poets known as the "post-Misty" school, the second wave of poets to emerge in the 1980s in the warming political climate after the end of the Cultural Revolution. The first wave, whose representative poets included Duo Duo, Gu Cheng and, most prominently, Bei Dao, transmuted the surrealism of French and Latin American poetry into a vehicle for political allegory. The Chinese authorities, flummoxed by their cryptic language but sensitive to its subversive undertones, disparaged it as *menglong*, an adjective meaning "vague" or "obscure" but initially mistranslated into English as "misty." The name stuck, and the successors to the Misty Poets—Xi Chuan, Zhai Yongming, Ouyang Jianghe, and others—inherited both the name and the hermetic language of their forebears, adapting it to discuss purer aesthetic and philosophical concerns. In the wake of Tiananmen, hermeticism became even more pronounced, the hallmark of a poetry overshadowed by the threatening clouds of redoubled censorship.

Ouyang Jianghe is regarded as the most hermetic of the Chinese hermetic poets, the mistiest of the post-Misties. His poetry is noted for its "difficulty"—the same word that in English we sometimes apply to poets like Wallace Stevens, Hart Crane, Fanny Howe, Michael Palmer, and others. Like

these poets he strives toward a sense beyond sense, inventing an idiosyncratic language that reveals its own logic only gradually after reading many of his poems.

"Phoenix," which Ouyang wrote in 2010 after a silence of almost two decades, is in a sense the culmination of his experiment. Where in the eighties and nineties he produced a body of poems distinguished by their length, technical intricacy, and high degree of abstraction, he has, in his recent work, taken this project to a new level, writing book-length poems of densely interlinked stanzas rife with wordplay, a fugue-like development of motifs, and the technique of argument by paradox—known in Chinese as *beilun* 悖论— employed by the philosopher Zhuangzi 庄子 to capture the illogical logic of Daoism. "Phoenix," a mini-epic ekphrastic poem written as a companion piece to Xu Bing's sculpture of the same name, multiplies the complexity of his earlier poems by an order of magnitude. It is, by his own account, his magnum opus. Synthesizing his earlier concerns of the materiality of language, the Chinese literary legacy, and the role of art in society into a sustained meditation on the theme of flight, it reflects two and a half decades of work refining the "obscure" language of Misty poetry into a vessel for sophisticated philosophical inquiry.

The Phoenix installation began with a request for Xu Bing to construct a monumental piece for Beijing's central business district. After meeting with a number of migrant workers brought in to construct the new face of Beijing, Xu Bing was struck by the social disparities between these two worlds and decided to develop his work from the scrap metal and detritus scattered throughout building sites. As with the underlying concept of Xu Bing's first major solo Hong Kong exhibition, *It Begins with Metamorphosis*, the Phoenix is a tangible example of the frenetic pace of China's modernization, refracting the complexities of a globalizing society through the mythological figure of the phoenix. Fan blades, hammers, lead pipes, rubber tubing and an assortment of lights coalesce into fluid organic figures that appear to be constantly evolving.

Assembled over two years, each phoenix weighs approximately 12 tons and measures between 90 and 100 feet long. The male phoenix *Feng* and female *Huang* already have found themselves suspended against a Shanghai skyline; exhibited at MASS MoCA in North Adams, Massachusetts; and most recently, perched in the austere confines of the cathedral of St. John the Divine in New York City. In each of these settings the phoenixes speak of the cycle of wealth accumulation, waste, reappropriation, and relocation that over the past three decades has consumed East Asia from the Gobi to the Pacific. And in each of these settings the mythical creatures resonate with and reflect back images of the societies they inhabit, similar to the way Ouyang's poetry invites a myriad of interpretations. In "Phoenix," Ouyang mirrors the process of appropriation and reuse that Xu Bing employed to create his sculpture, recycling language, rather than objects, to construct an ambiguous monument to the transition from the traditional to the modern and global, a verbal assemblage intended to stand alongside Xu Bing's physical one.

The trouble with translating poetry as complex and ambiguous as Ouyang's is that, like so much of the poetry that we often term "experimental" or "difficult," it relies upon chance associations between words particular to the language in which it was written. Imagine the difficulty a Chinese translator might face in handling the following lines from the American poet Michael Palmer:

> "I said darkling and you said sparkling"
> The play-house appears before us
> as a real house in the dark

Even if the translator were to find Chinese words that exactly capture the meanings of "darkling" and "sparkling," the line would probably make no sense, because its logic, and its cleverness—its very reason for being—lie in the chance convergence of the sounds and meanings of two etymologically unrelated English words. Say, then, that the translator found a clever pair of Chinese words meaning more or less "dark" and "bright." At that point, there's no guarantee that the "bright" word would convey the same overtones of playfulness as "sparkling" does in English, because of which overtones, one might argue, the second line follows from the first. Furthermore, in English, we speak of the "play" of light and dark, and one might posit that our sense of light and dark as "playing" animates these three lines. There's no guarantee that the Chinese use the same word to describe the "play" of light and shadow and the play of children, and again, the lines

are in danger of losing their logic, the resonance of meaning that makes them poetry.

These linguistic convergences lie as randomly as the crossed sticks of the *I Ching*, but they're as fundamental to this kind of poetry as the studs of a house. When poetry sheds the traditional devices of scene and story, then double meanings, sonic affinities, and densely interwoven metaphors often become the organizing principles of the poem. It's perhaps no surprise that poets like Ouyang, in seeking to reduce poetry to its purest essence, come to rely on such "untranslatable" effects.

All of this creates either a heaven or a headache for the translator, depending on your point of view. Take, for example, the following lines from stanza eight of "Phoenix":

> 一些我们称之为风花雪月的东西
> 开始漏水，漏电，
> 人头税也一点点往下漏，
> 漏出些手脚，又漏出鱼尾
> 和屋漏痕，它们在鸟眼睛里，一点点
> 聚集起来，形成山河，鸟瞰。

In these lines, a sequence of six nouns are said to "drip" or "leak" from an unnamed object that humans call *fenghuaxueyue* (a traditional idiom typically used to describe writing that is precious and overly baroque writing). These nouns are *shui* 水 (water), *dian* 电 (electricity), *rentoushui* 人头税 (poll tax or head tax), *shoujiao* 手脚 (lit. "hands-and-feet," i.e., tricky or underhanded behavior), *yuwei* 鱼尾 ("fishtails," a word that in

addition to its literal meaning can refer to an old-fashioned form of bookbinding as well as crow's feet wrinkles), and *wulouhen* 屋漏痕 ("water stains on the wall," i.e., the pattern of water dripping from a leak in the roof; to reproduce the natural beauty of such patterns is an ideal sought after by Chinese calligraphers). To the uninitiated eye—even to the eyes of many native Chinese speakers—this might seem like a random jumble of objects. The reader can only guess at the logic behind the progression of images, and many explanations are possible. The translator, who has to choose one of them and render it explicit, is left floundering in the dark.

However, I had the good fortune to be able to grill Ouyang for many hours over Skype, so I can actually trace the line of thought that resulted in this sequence. How we get from water to electricity is clear: both are things that can, literally, leak. From electricity to *rentoushui* is trickier: in Chinese, *loushui* 漏税 ("leak tax") is a verb meaning to evade taxation, so "leaking head tax" has the double meaning of "evading head tax." Moreover, these lines immediately follow the image of an elevator rising through the human anatomy to its snowcapped peak; i.e., the brain, so "head tax" follows naturally from the image of the head. From head tax to *shoujiao*, then, the connection is obvious: from the head to the hands and feet, from the thing evaded to the act of evasion. Then, from hands and feet to fishtails, we continue our litany of body parts; Ouyang notes that "crow's feet" is the intended primary meaning of *yuwei*. On a symbolic level, Ouyang explained to

me, *rentoushui* is like income tax, an unavoidable duty meted out to every citizen in a human society. Humans nonetheless exhaust themselves trying to trick (*shoujiao*) their way out of the fixed prices they must pay in life. In the process, they age, producing *yuwei*—wrinkles—and sometimes something more sublime: *wulouhen*, Art. And so this list traces the contour of human pursuits, and establishes a kind of origin myth for art.

This list encapsulates the sidestepping associative logic upon which much of the poem—much of Ouyang's poetry, in fact—is built, and which makes translating his poetry such a tricky endeavor. If I were to strive primarily for the literal meanings of these words, I'd end up with a list like this:

> Some things we call flowery and sentimental
> leak water, electricity, head tax,
> trickery, crows' feet,
> and water stains [. . .]

In English, this isn't a symbolic progression, it's a junkyard of unrelated nouns. The reader can't follow the steps of the dance; all the words are there, but the poetry is gone.

The trick, then, is to translate every word or phrase with an eye not to its *meaning* but to its *relationship* with the words or images surrounding it. This is the only way I can capture the intricate play of association and suggestion that drives the poem. At every step, I have to consider why a word or phrase was chosen—usually because it's etymologically or sonically

related to another word, or echoes a preceding metaphor—as well as the larger symbolic resonances intended, and find an English word that works on both levels. When I finally find a word that slips smoothly into the web of associations, and also serves Ouyang's symbolic choreography, it's like arriving at one of a finite set of solutions to a particularly tricky calculus problem. So here, finally, is the version I arrived at after much obsessive tinkering:

A thing we call lofty and remote
leaks water, power,
intelligence, tax dollars,
loopholes, wrinkles
and ink, collecting
drop by drop in the eyes of birds
as river-cut mountainscapes.

I won't tax the reader's patience by explaining each of my moves; I hope the reader, encountering this list for the first time in English, will sense a coherent logic behind the progression (not the same logic as Ouyang's, but the same kind of logic) and also recognize it as having a larger symbolic meaning.

After tracing the colorful contrails of meaning that radiate from the Chinese words, this English version might seem bare and boring, a pitiful stand-in for the teeming complexity of the original. But I've found that the best strategy for reproducing such complexity is to aim for the simplest, most basic meanings, the ones that fulfill each line's essential function, and let the whole cascade of secondary associations fall where it may. I find that if I bear in mind the larger philosophical argument of the poem, the translation develops a life of its own, sprouting subtleties and interconnections particular to the English words. The Chinese word *dian* 电 (electricity) lacks the double meaning of the English "power," so the sly pivot from "water" to "power" to "tax dollars" is unique to the English version; the same goes for the sonic echo of "wrinkles" and "ink." In this way, the text naturally regains some of the density of association that it lost in passing out of Chinese.

In all this, I have to strive to preserve the poem's mystery. The beauty of a poem by Wallace Stevens lies in its riddle-like quality, in the tantalizing glimmer of truths half-revealed. Even though Ouyang has explained to me in great detail the logic by which he arrived at most of these lines, I must show only enough to tempt the imagination, leaving room for a multiplicity of readings. A good "hermetic" poem is like a mirror, inviting the reader to see in it what she wishes; it's a tool for contemplation, a mandala or a maze among whose many turnings the reader can pick her own path.

That said, I'm sensitive to the fact that the insularity of many of the poem's references—to other poetry, both Chinese and Western, and to details about the creation of the Phoenix sculpture that no one outside Xu Bing's studio could hope to know—render vast swaths of this poem incomprehensible to the general reader. Believing that just an ounce of background will go a long way to making the poem meaningful, I've

provided endnotes to illuminate the most abstruse bits.

One dirty secret about literary translation is that no matter how fluent one is in a foreign language, one's sensitivity of the subtleties of a text will be hopelessly crude compared to that of a native speaker's. Translating a poem like this requires hours of conversation with knowledgeable "informants," and I'm lucky to have had both the endless patience and cooperation of Ouyang, who endured almost nightly questioning during the months that I worked on the poem, and of Lydia Liu, whose sensitivity as a reader of both Chinese and English held me to exacting standards. I'm indebted to them, to Cris and Leora at Zephyr, and of course to Xu Bing's studio, without whose support this project wouldn't have been possible.

Those interested in learning more about "post-Misty" poetry and Ouyang's role within it would do well to read Wolfgang Kubin's introduction to *Doubled Shadows: Selected Poetry of Ouyang Jianghe* (Zephyr, 2012) and Michael Day's panoramic scholarly survey *China's Second World of Poetry: The Sichuan Avant-Garde, 1982–1992* (Digital Archive for Chinese Studies, Leiden University, 2005).

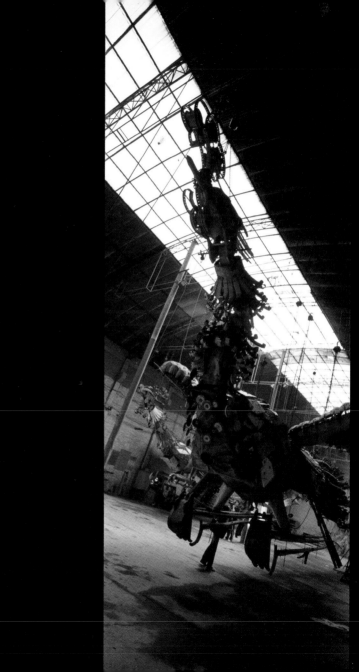

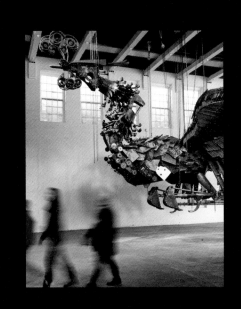

给从未起飞的飞翔
搭一片天外天，
在天地之间，搭一个工作的脚手架。
神的工作与人类相同，
都是在荒凉的地方种一些树，
炎热时，走到浓荫树下。
树上的果实喝过奶，但它们
更想喝冰镇的可乐，
因为易拉罐的甜是一个观念化。
鸟儿衔萤火虫飞入果实，
水的灯笼，在夕照中悬挂。
但众树消失了：水泥的世界，拔地而起。
人不会飞，却把房子盖到天空中，
给鸟的生态添一堆砖瓦。
然后，从思想的原材料
取出字和肉身，
百炼之后，钢铁变得袅娜。
黄金和废弃物一起飞翔。
鸟儿以工业的体量感
跨国越界，立人心为司法。
人写下自己：凤为撇，凰为捺。

For earthridden flight,
build a separate sky.
Between earth and sky, build a scaffold.
Divine and human work are alike:
plant trees in a dry place, and in summer
take refuge from the heat.
Trees whose fruits have drunk milk, but would sooner
pop open a cold soda
and taste conceptual sweetness.
Aqueous lanterns hang in the dusk.
Inside them birds wing, glowworms in their beaks.
The forest is gone now; a cement world looms.
Flightless, we build homes in the sky,
adding brick and tile to the ecology of the birds.
Then, from raw thought,
we extract letters and flesh,
refine steel into litheness. Gold and waste soar.
A bird of vast industrial scale
unites nations beneath the laws of heart and mind.
Man writes phoenix
in Man's own sign.

人类并非鸟类，但怎能制止
高高飞起的激动？想飞，就用蜡
封住听觉，用水泥涂抹视觉，
用钢钎往心的疼痛上扎。
耳朵聋掉，眼睛瞎掉，心跳停止。
劳动被词的膂力举起，又放下。
一种叫做凤凰的现实，
飞，或不飞，两者都是手工的，
它的真身越是真的，越像一个造假。
凤凰飞起来，茫然不知，此身何身，
这人鸟同体，这天外客，这平仄的装甲。
这颗飞翔的寸心啊，
被牺牲献出，被麦粒洒下，
被纪念碑的尺度所放大。
然而，生活保持原大。
为词造一座银行吧，
并且，批准事物的梦幻性透支，
直到飞翔本身
成为天空的抵押。

We aren't birds, but we cannot resist
the urge to soar. To fly, stifle
hearing with wax, seal sight with cement,
drill a spike through pain's throbbing heart.
Ears fade, eyes darken, pulse halts.
Words hoist labor, then set it down.
This reality called phoenix
where flight and flightlessness are both manmade:
the more real its embodiment, the more fabricated it seems.
Senseless, selfblind, the phoenix takes wing.
Man-bird, extracelestial pilgrim, prosodic carapace.
Winged sentiment
offered in sacrifice, scattered in grain,
enlarged in a monument's proportions.
But life's magnitude remains unchanged.
Build a bank for words, then authorize
overdrafts for the illusory nature of things,
till for the sky's sake
we have to mortgage flight.

身轻如雪的心之重负啊，
将大面积的资本化解于无形。
时间的白色，片片飞起，
并且，在金钱中慢慢积蓄自己，
慢慢花光自己。而急迫的年轻人
慢慢从叛逆者变成顺民。
慢慢地，把穷途像梯子一样竖起，
慢慢地，登上老年人的日落和天听。
中间途经大片大片的拆迁，
夜空般的工地上，闪烁着一些眼睛。

Crushing snowdust of human care:
melt capital's square footage
till it becomes intangible.
The whiteness of time swirls slowly upward,
accumulating and spending itself
in wealth. Impatient youth
turn slowly from rebels to peons,
then, slowly, turn hope on its end like a ladder
and climb to the twilit gospels of age.
Passing through the rubble of perpetual demolition:
eyes glitter in the night's construction site.

4

那些夜里归来的民工，
倒在单据和车票上，沉沉睡去。
造房者和居住者，彼此没有看见。
地产商站在星空深处，把星星
像烟头一样掐灭。他们用吸星大法
把地火点燃的烟花盛世
吸进肺腑，然后，优雅地吐出印花税。
金融的面孔像雪一样落下，
雪踩上去就像人脸在阳光中
渐渐融化，渐渐形成鸟迹。
建筑师以鸟爪蹀足而行，
因为偷楼的小偷
留下基建，却偷走了它的设计。
资本的天体，器皿般易碎，
有人却为易碎性造了一个工程，
给它砌青砖，浇铸混凝土，
夯实内部的层叠，嵌入钢筋，
支起一个雪崩般的镂空。

Workers go home and fall
fast asleep among receipts and ticket stubs.
Builders and tenants never meet.
Real estate moguls stand in the sky,
extinguishing stars like cigarette butts.
Masters of astrospiration, they breathe in
booming phosphorescent flowers
and blow money-laundering rings.
The face of finance blankets the earth,
melting underfoot like sunlit features
into birdprints. The architect
runs on clawed feet: structural burglars
have stolen the designs, leaving just buildings.
The spheres of capital are as fragile as porcelain,
but some turn fragility into a feat of engineering,
laying bricks, pouring concrete
in dense rebarred layers
to hold up an avalanche of empty space.

得给消费时代的CBD景观
搭建一个古瓮般的思想废墟，
因为神迹近在身边，但又遥不可及。
得给人与神的相遇，搭建一个
人之境，得把人的目力所及
放到凤凰的眼瞳里去，
因为整个天空都是泪水。
得给"我是谁"
搭建一个问询处，因为大我
已经被小我丢失了。
得给天问，搭建鹰的独语，
得将意义的血肉之躯
搭建在大理石的永恒之上，
因为心之脆弱有如纹瓷，
而心动，不为物象所动。

For consumer-era skylines
build a chipped vessel of thought,
because the miracle is near but unreachable.
For the meeting of human and divine, build
a human heaven, place the human eye's sweep
inside the phoenix's pupil
because the sky is nothing but tears.
For "Who am I," build an information booth
because the self has lost the Self,
and for questions without answers, erect
aquiline soliloquies, build boned, tissued meaning
atop the marble of eternity,
because the heart's frailty is an antique vase
that can't be touched
by objective truth.

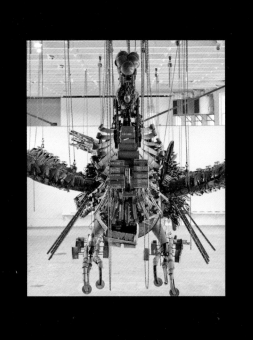

人类从凤凰身上看见的
是人自己的形象。
收藏家买鸟，因为自己成不了鸟儿。
艺术家造鸟，因为鸟即非鸟。
鸟群从字典缓缓飞起，从甲骨文
飞入印刷体，飞出了生物学的领域。
艺术史被基金会和博物馆
盖成几处景点，星散在版图上。
几个书呆子，翻遍古籍
寻找千年前的错字。
几个临时工，因为童年的恐高症
把管道一直铺设到银河系。
几个乡下人，想飞，但没机票，
他们像登机一样登上百鸟之王，
给新月镀烙，给晚霞上釉。
几个城管，目送他们一步登天，
把造假的暂住证扔出天外。
证件照：一个集体面孔。
签名：一个无人称。
法律能鑑别凤凰的笔迹吗？
为什么凤凰如此优美地重生，
以回文体，拖曳一部流水韵？

In the phoenix we see our own reflection.
Collectors buy birds because they can't be them.
Artists make birds because birds aren't birds.
Birds fly from the dictionary, flocking off of turtle shells
into block letters, leaving the biological realm.
Museums and foundations construct art history
in tourist destinations scattered across a map.
Scholars fan yellowed pages searching for seminal typos.
Day laborers driven by childhood acrophobia
lay plumbing to the Milky Way.
Country folk without boarding passes
who instead flew King of All Birds,
chromeplate the moon, lacquer the sunset.
Policemen watch their meteoric rise
and toss fake residence permits into the firmament.
ID photos: a collective face.
Signatures: an anonymity.
Can the law differentiate the handwriting on the phoenix?
Why is the phoenix always reborn so beautiful,
clad in rippling mellifluidities?

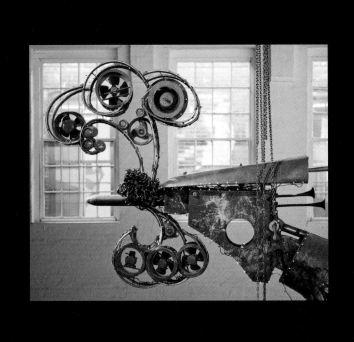

转世之善，像衬衣一样可以水洗，
它穿在身上就像沥青做的外套，
而原罪则是隐身的
或变身的：变整体为部分，
变贫穷为暴富。词，被迫成为物。
词根被银根攥紧，又禅宗般松开。
落槌的一瞬，交易获得了灵魂之轻，
把一个来世的电话打给今生。

Karmic virtue can be washed like a shirt
or worn like a tarpaper jacket,
but original sin metamorphoses
and vanishes, turns whole into parts,
rags into returns. Words are forced to be things.
Their roots are squeezed by the market, then, Zen-like,
released. At the crack of the hammer,
the transaction acquires the spirit's lightness
and dials this world from the next.

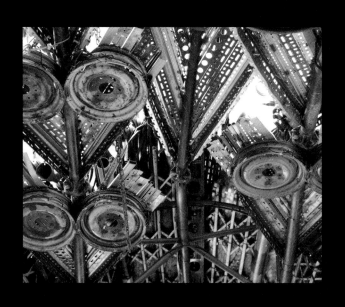

人是时间的秘书，搭乘超音速
起落于电话线两端：打电话给自己
然后到另一端接听。但鸟儿
没有固定电话。而人也在
与神相遇的路上，忘记了从前的号码。
鸟儿飞经的所有时间
如卷轴般展开，又被卷起。
三两支中南海，从前海抽到后海，
把摩天楼抽得只剩抽水马桶，
把鹤寿抽成了长腿蚊。
一点余烬，竟能抽出玉生烟，
并从水泥的海拔，抽出一个珠峰。

We are time's secretaries, traveling supersonically
along telephone wires, calling ourselves
and answering at the other end. But birds
don't have landlines. And on the way to meet the divine
we forget the numbers at which we used to be reached.
All time through which birds fly
can be unrolled and rolled back up like a scroll.
Smoke a couple Zhongnanhais
while strolling from Qianhai to Houhai,
smoke skyscrapers down to drainage pipes
and a crane's longevity to a fly's long legs.
But ashes breathe forth sublimated jade
and Everests rise from the elevation of cement.

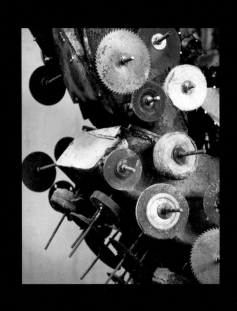

升降梯，从腰部以下的现实
往头脑里升，一直上升到积雪和内心
之峰顶，工作室与海
彼此交换了面积和插孔。
一些我们称之为风花雪月的东西
开始漏水，漏电，
人头税也一点点往下漏，
漏出些手脚，又漏出鱼尾
和屋漏痕，它们在鸟眼睛里，一点点
聚集起来，形成山河，鸟瞰。
如果你从柏拉图头脑里的洞穴
看到地中海正在被漏掉，
请将孔夫子塞进去，试试看
能堵住些什么。天空，锈迹斑斑：
这偷工减料的工地。有人
在太平洋深处安装了一个地漏。

The elevator climbs from a nether reality
to the brain, to the snowcapped peak
of being, and the studio swaps
its electrical outlets
with the ocean in exchange for its footprint.
A thing we call lofty and remote
leaks water, power,
intelligence, tax dollars,
loopholes, wrinkles
and ink, collecting
drop by drop in the eyes of birds
as river-cut mountainscapes.
If, peering out of the cave in Plato's head,
you see the Mediterranean has sprung a leak,
try plugging it with Confucius, see
what he can stop. Rust-spotted sky:
shoddy construction site. Someone
has installed a drain in the Pacific floor.

铁了心的飞翔，有什么会变轻吗？
如果这样的鸟儿都不能够飞，
还要天空做什么？
除非心碎与玉碎一起飞翔，
除非飞翔不需要肉身，
除非不飞就会死：否则，别碰飞翔。
人啊，你有把天空倒扣过来的气度吗？
那种把寸心放在天文的测度里去飞
或不飞的广阔性，
使地球变小了，使时间变年轻了。
有人将飞翔的胎儿
放在哲学家的头脑里，
仿佛哲学是一个女人。
有人将万古交给人之初保存。
有人在地书中，打开一本天书。

Where's the lightness in this steely flight?
If this bird is flightless,
what good is the sky?
Unless grief and apotheosis fly together,
unless one can fly bodiless,
unless not flying is dying,
don't touch flight. Human being:
do you have the breadth of heart
to flip the sky? The vistas required
to let pinprick emotion wing or not-wing
in astronomical spans,
shrinking the earth, making time young?
Some plant the embryo of flight
in a philosopher's brain,
as if philosophy were a woman.
Some hand the immemorial to the human for safekeeping.
In the earth's book, some open a book of sky.

古人将凤凰台造在金陵，也造在潮州，
人和鸟，两处栖居，但两处皆是空的。
庄子的大鸟，自南海飞往北海，
非竹不食，非泉不饮，非梧桐不栖，
不知腐鼠和小官僚的滋味。
李贺的凤凰，踏声律而来，
那奇异的叫声，叫碎了昆仑玉，
二十三根琴弦，弹得紫皇动容，
弹断了多少人的流水和心肠。
那时贾生年少，在封建中垂泪，
他解开凤凰身上的扣子，
脱下山鸡的锦缎，取出几串孔雀钱，
五色成文章，百鸟寄身于一鸟。
晚唐的一半就这样分身给六朝的一半，
秋风吹去尘土，把海吹得直立起来，
黄河之水，被吹作一个立柱。
而山河，碎成鸟影，又聚合在一起。
以李白的方式谈论凤凰过于雄辩，
不如以韩愈的方式去静听：
他从颍师的古琴，听到了孤凤凰。
不闻凤凰鸣，谁说人有耳朵？
不与凤凰交谈，安知生之荣辱？
但何人，堪与凤凰谈今论古。

The ancients built terraces at Jinling and Chaozhou
for the phoenix: two human-bird roosts, both vacant.
Zhuangzi's bird flew from southern sea to north,
drinking only from clear springs, perching only on the wutong,
untainted by the taste of mice and bureaucrats.
Li He's phoenix walked in lilting cadence,
strange cries shattering jade,
striking gods dumb with its twenty-three stringed voice,
leaving caesuras in rivers, syncopes in hearts.
Weeping tears against princes, young Jia Yi
unbuttoned the phoenix, stripped the pheasant's brocade,
tore off peacock medallions, treatises on rainbows, an aviary of one—
half the body of the Tang Dynasty, bodied back the Six.
Wind sweeps away the dust, blows oceans erect,
stands the Yellow River on end like a pillar.
Geographies scatter, then alight.
Perhaps Li Bai's bluster doesn't suit the phoenix
as well as Han Yu's rapt silence:
in Master Ying's qin, he heard a lone phoenix cry.
How can one who hasn't listened to the phoenix
know whether he has ears?
How can one who hasn't conversed with the phoenix
know whether it is grace or disgrace we live in?
But to whom among us is that given?

郭沫若把凤凰看作火的邀请。
大清的绝症，从鸦片递给火，
从词递给枪：在武昌，凤凰被扣响。
这一身烈火的不死鸟，
给词章之美穿上军装，
以迷彩之美，步入天空。
风像一个演说家，揪住落叶的耳朵，
一头撞在子弹的繁星上。
一代凤凰党人，撕开武器的胸脯，
用武器的批判撕碎一纸地契。
灰烬般的火凤凰，冒着乌鸦的雪，深深落下。
如果雪不是落在土地的契约上，
就不能落在耕者的土地上，
不能签下种子的名字。
如果词的雪不是众声喧哗，
而是嘘的一声，心，这面死者的镜子，
将被自己摔碎。而在准星上，猎手
将变得和猎物越来越像。

For Guo Moruo, the phoenix was an invitation from fire.
The Qing cancer passed from opium into flames,
words into guns: at Wuchang, the phoenix thundered.
Deathless blaze of a bird, dressing euphonies in fatigues
to storm the sky in exquisite camouflage.
Wind, like an orator, seizes the ears of falling leaves
and rattles constellations of bullets.
A generation of phoenicists tear open the chests
of violence, shred deeds with the weapon's critiques.
Through sooty blizzards, a bird plummets in embers.
If snow doesn't fall on land contracts,
it cannot fall on the tiller's soil,
can't sign seed's name. If words fall
not with a clamor, but a whisper—
then the heart, Death's mirror, will have been shattered
by itself. And in the crosshairs
hunter and hunted will look more and more alike.

政治局被一枚硬币抛向天空，
至今没有落地：常委们
会一直待在云深处吗？
列宁和托派，谁见到过凤凰？
革命和资本，哪一个有更多乡愁？
用时间所屈服的尺度
去丈量东方革命，必须跳出时间。
哦，孤独的长跑者
像一个截肢人坐在轮椅上，
感觉深渊般的幻肢之痛
有如一只黑豹，仍然在断腿上狂奔。
蹉跎的时空之旅，结束在开端。
有人在二十一世纪，读春秋来信。
有人在北京，读巴黎手稿。
更多的人坐在星空
读资本论。
"读，就是和写一起消失。"

A coin throws the Politburo into the sky:
how long till its members
drop back down out of the clouds?
Did Lenin see the phoenix? Did the Trotskyites?
Revolution or Capital—which yearns more for its roots?
To measure a revolution in the East
on a scale to which Time genuflects
one has to leap free of time. Behold the lone runner:
a wheelchair-bound amputee
feeling an abyssal, phantom pain
racing like a panther in his severed legs.
The squandering of spacetime ends at its beginning.
In the twenty-first century, some read pre-Qin letters.
In Beijing, some read the Paris manuscripts.
Many more sit in the night sky
reading *Das Kapital*.
"To read is to disappear with writing."

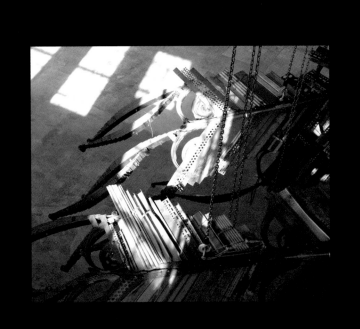

孩子们在广东话里讲英文。
老师用下载的语音纠正他们。
黑板上，英文被写成汉字的样子。
家长们待在火柴盒里，
收看每天五分钟的国际新闻，
提醒自己——
如果北京不是整个世界，
凤凰也不是所有的鸟儿。
十年前，凤凰不过是一台电视。
四十年前，它只是两个轮子。
工人们在鸟儿身上安装了刹车
和踏瓣，宇宙观形成同心圆，
这26吋的圆：毛泽东的圆。
穿裤子的云，骑凤凰女车上班，
云的外宾说：它真快，比飞机还快。
但一辆自行车能让时间骑多远，
能把凤凰骑到天上去吗？

Children speak English in Cantonese.
Teachers correct them with downloaded diction,
scribbling ideographic ABCs.
Parents in matchboxes
tune to five-minute global newscasts
with dawning certainty
that on a planet larger than Beijing
the phoenix can't be the only bird.
Ten years ago, it was a TV station.
Thirty years before that, it was just a pair of wheels.
Workers give birds brakes
and pedals: worldviews turn
in concentric, 26-inch ideological circles.
A cloud in trousers rides a Phoenix to work.
A cloud-tourist says: That's faster than a plane!
But how far can a bicycle carry time?
Can it pedal the phoenix into the sky?

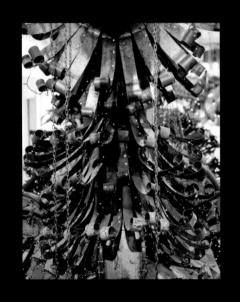

然后轮到了徐冰。瞧，他从鸟肺
掏出一些零配件的龙虾，
一些次第的芯片，索隐，火力，
（即使拆除了战争，也要把凤凰
组装得像一支军队）。
他从内省掏出十来个外省
和外国，然后，掏出一个外星空。
空，本就是空的，被他掏空了，
反而凭空掏出些真东西。
比如，掏出生活的水电，
但又在美学这一边，把插头拔掉。
掏出一个小本，把史诗的大部头
写成笔记体：词的仓库，搬运一空。
他组装了王和王后，却拆除了统治。
组装了永生，却把它给了亡灵。
组装了当代，却让人身处古代。
这白夜的菊花灯笼啊。这万古愁。
这伤痕累累的手艺和注目礼。
凤凰彻悟飞的真谛，却不飞了。

Now we turn to Xu Bing. See how from bird entrails
he pulls crustacean components,
strings of microchips, annotations, ammunition
(because, even after the dismantling of war,
one must assemble a phoenix like an army); watch
as from inner realities he pulls far-flung provinces,
foreign nations, outer space.
Ransacks the void till no emptiness remains,
while prestidigitating truths from thin air;
conjures the water and electricity of Life
then walks over to Aesthetics and pulls the plug.
Pulls out a notebook, writes multivolume epics
in shorthand, depleting a whole warehouse of words.
Assembles a royal couple, but dismantles authority.
Assembles eternity, but hands it to the dead.
Assembles the contemporary, but places us in the past.
O chrysanthemum lantern, light of white nights.
O immemorial pain. Scarred craft, scarred eye.
The phoenix knows what it means to fly, but doesn't.

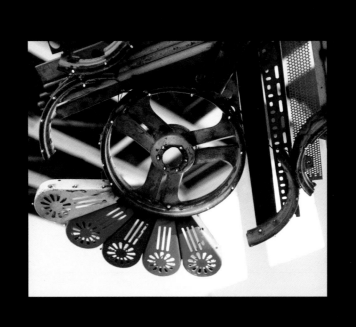

李兆基之后，轮到了林百里。
鹤，无比优雅地看着你，
鹤身上的落花流水
让铁的事实柔软下来。
凤凰向你走来，浑身都是施工。
那么，你会为事物的多重性买单，
并在金钱的匿名性上签名吗？
无法成交的，只剩下不朽。
因为没人知道不朽的债权人是谁。
与不朽者论价，会失去时间，
而时间本身又过于耽溺。
慢，被拧紧之后，比自身快了一分钟。
对表的正确方式是反时间。
一分钟的凤凰，有两分钟是恐龙，
它们不能折旧，也不能抵税。
时间和金钱相互磨损，
那转身即逝的，成为一个塑造。

Now we turn to Barry Lam and Lee Shau-kee.
The crane eyes you alluringly,
its lofty mien, its lissome grace
soften the fact of iron.
The phoenix approaches, its body a construction zone.
Now, will you purchase the multiplicity of things,
sign your name to the anonymity of money?
Only the everlasting can't change hands,
because nobody knows who its lender is.
To haggle with the undying is to lose time,
and time itself is merely a dalliance.
Slowness, when wound, is a minute faster than itself.
True synchrony is anti-time.
One minute of the phoenix equals two of the dinosaur,
both nondepreciating, nondeductible.
Time and money wear each other away
and what vanishes becomes a representation.

然后，轮到了观者：众人与个别人。
登顶众口之言无足轻重，
一人独语，又有些孤傲。
人，飞或不飞都不是凤凰，
而凤凰，飞在它自己的不飞中。
这奥义的大鸟，这些云计算，
仅凭空想，不可能挪移乾坤。
飞向众生，意味着守身如一。
因此，它从先锋飞入史前物种，
从无边的现实飞入有限，
把北京城飞得比望京还小，
一个国家，像一片树叶那么小。
陆宽和黄行，从鸟胎取出鸟群，
却不让别的人飞，他们自己要飞。

Now we turn to the viewer, collective and individual.
Scaling a hubbub is meaningless,
but to soliloquize is standoffish.
Whether we fly or not, we aren't phoenixes;
a phoenix flies in its own flightlessness.
This avian exegesis, this cloud-computing
can't, by pure thought, shift the heavens.
Flying toward the living means remaining singular.
So the phoenix flies from the avant-garde
into extinction, from limitless reality to the limited;
its flight shrinks Beijing smaller than Wangjing,
nations to the size of leaves. Lu Kuan
and Huang Xing pull flocks from a bird's embryo,
wanting nobody to fly but themselves.

然后，轮到人类以鸟类的目光
去俯瞰大地的不动产：
那些房子，街道，码头，
球场和花园，生了根的事物。
一切都在移动，而飞鸟本身不动。
每样不飞的事物都借凤凰在飞。
人，不是成了鸟儿才飞，
而是飞起来之后，才变身为鸟。
不是飞鸟在飞，是词在飞。
所谓飞翔就是把人间的事物
提升到天上，弄成云的样子。
飞，是观念的重影，是一个形象。
不是人与鸟的区别，而是人与人的区别
构成了这形象：于是，凤凰重生。
鸟类经历了人的变容，
变回它自己：这就是凤凰。
它分身出一个动物世界，
但为感官之痛，保留了人之初。
痛的尖锐
触目地戳在大地上，
像一个倒立的方尖碑。

Now it's our turn to borrow birds' eyes
and gaze upon the immovable property of the earth:
houses, avenues, wharves,
stadiums and gardens, rooted things.
Everything moves; the bird remains motionless.
Every flightless thing flies by means of the phoenix.
It's not that we become birds in order to fly
but that, in flying, we become them.
Birds don't fly; words fly.
Flight is to take a human thing
and raise it skyward, make it cloudlike.
Flight is a conceptual double image.
Created not by the difference between human and bird
but between human and human: this is rebirth.
A bird transfigured by the human race
back into itself: this is the phoenix.
Incarnate in the animal kingdom
but retaining humanity for the sake of pain.
The sharpness of pain
sticks conspicuously in the earth
like an inverted obelisk.

为最初一瞥，有人退到怀古之思的远处 。
但在更远处，有人投下抽丝般的
逝者的目光。神的鸟儿，
飞走一只，就少一只。
但凤凰既非第一只这么飞的鸟，
也非最后一只：几千年前，
它是一个新闻，被尔雅描述过。
百代之后，它仍然会是新闻，
因为每个时代的新闻，都只报道古代。
那么，请将电视和广播的声音
调到鸟语的音量：听一听树的语言，
并且，从蚜虫吃树叶的声音
取出听力。请把地球上的灯一起关掉，
从黑夜取出白夜，取出
一个火树银花的星系。
在黑暗中，越是黑到深处，越不够黑。

With a single glance, some retreat to the distance of memory.
But from a greater distance, others unspool
the long gazes of the dead. A divine bird flown
is one divine bird less. But the phoenix
isn't the first bird to fly this way,
or the last: twenty centuries ago
it was news, reported in the *Erya*.
Twenty centuries from now it will still be news,
because every century's news just reports the past.
Now, please turn your TVs and radios
down to the volume of birdsong, listen
to the speech of trees, and from an aphid's tooth
extract hearing. Turn off the earth's lights
and receive the night's whiteness:
the flowering of galaxies.
The deeper the darkness, the less complete.

19

凤凰把自己吊起来，
去留悬而未决，像一个天问。
人，太极般点几个穴位，把指力
点到深处，形成地理和剑气。
大地的心电图，安顿下来。
天空宁静得只剩深蓝和深呼吸，
像植入晶片的棋局，下得斗换星移，
却不见对弈者：闲散的着法如飞鸟，
落子于时间和棋盘之外。
不飞的，也和飞一起消失了。
神抓起鸟群和一把星星，扔得生死茫茫。
一堆废弃物，竟如此活色生香。
破坏与建设，焊接在一起，
工地绽出喷泉般的天象——
水滴，焰火，上百万颗钻石，
以及成千吨的自由落体，
以及垃圾的天女散花，
将落未落时，突然被什么给镇住了，
在天空中
凝结成一个全体。

Between present and absent, the phoenix hangs
self-suspended, like a question posed to the heavens.
Human fingers press deep along meridian lines,
forming geographies, virtuosities.
The earth's EKGs fall into a regular rhythm.
The sky stills to deep blue, deep breath,
an LED-implanted game of chess
whose moves are like the unhurried circling of birds,
spinning itself out, playerless, on no board, beyond Time.
The flightless, together with flight, disappear.
A divine hand scatters stars and birds like ash:
such vitality, in this heap of trash.
Wrecking and building are welded together,
and from the construction site, celestial fountains leap—
water droplets, pyrotechnics, diamond showers,
gargantuan bodies in freefall,
cascades of debris like angel-tossed petals:
the instant before they hit the ground, they're transfixed
by a mysterious power
and hang frozen, unified
in midair.

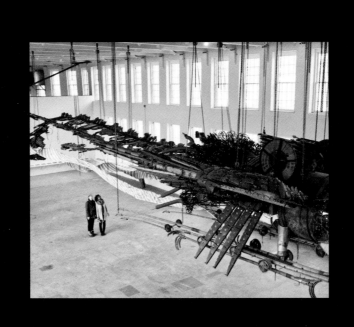

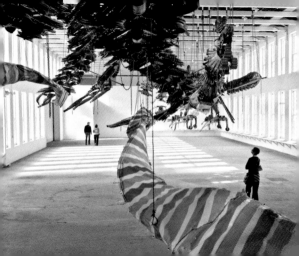

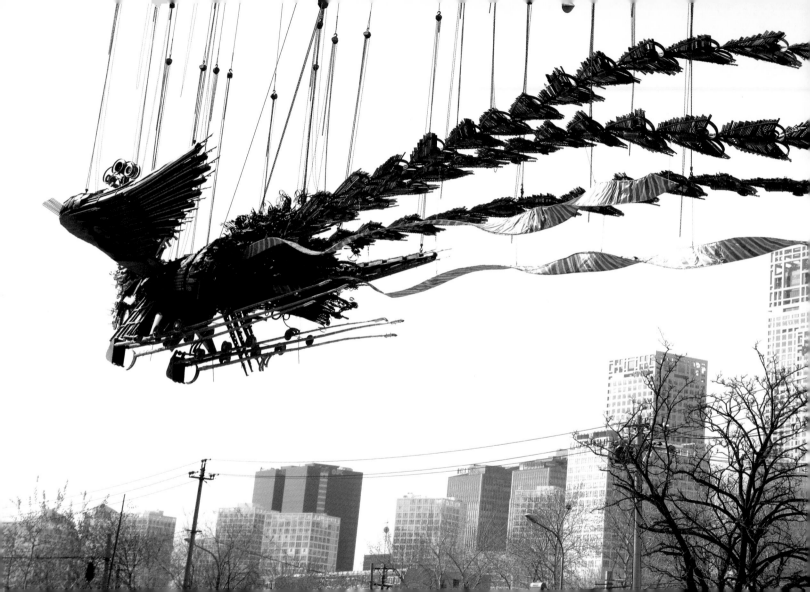

Notes

1

Man writes phoenix / in Man's own sign

In Chinese: "Humanity writes itself: *feng* as *pie*, *huang* as *na* 凤为撇，凰为捺." *Feng* and *huang* are the male and female forms of the phoenix; combined, they form the species name, *fenghuang*. *Pie* and *na* are the leftward and rightward downward brushstrokes in calligraphy: 丿 and 乀. Together, they form the character *ren* 人: man, human, person. The two strokes that make up the character for *humanity* are therefore said to be the two halves, masculine and feminine, of the phoenix.

4

Astrospiration

Xi xing dafa 吸星大法, literally "The Great Dharma of Inhaling Stars," is a fictional martial arts technique from the novels of Jin Yong, used to deplete an opponent's strength and channel it into one's own.

5

Aquiline soliloquies

Refers obliquely to Xi Chuan's poem *Ying de Huayu* 《鹰的话语》 translated variously as "Eagle's Words" and "What the Eagle Says."

6

Birds fly from the dictionary, flocking off of turtle shells / into block letters

Alludes to Xu Bing's installation "The Living Word": hundreds of wood cutouts of the Chinese character for "bird," 鸟, hanging from the ceiling by transparent wires, which appear to rise in a flock off the page of a dictionary, metamorphosing from oracle bone script through various calligraphic styles into modern script. Oracle bone inscriptions were often carved on turtle shells.

7

Smoke a couple Zhongnanhais / while strolling from Qianhai to Houhai

Zhongnanhai—"Middle South Lake"—is a common brand of cigarettes, and also the compound in central Beijing that serves as the Communist Party headquarters. Qianhai and Houhai are lakes just north of Zhongnanhai, surrounded by a traditional *hutong* neighborhood that is now a fashionable bar-and-nightclub district.

A fly's long legs

See "Long-legged Fly," by W. B. Yeats.

Sublimated jade

Literally "smoke from jade" or "mist from jade," the phrase *yu sheng yan* 玉生烟 comes from the famous poem "The Brocade Zither" 《錦瑟》 by the Tang poet Li Shangyin.

The ancients built terraces at Jinling and Chaozhou / for the phoenix
Alludes to two places named *Fenghuangtai* 凤凰台, "Phoenix Terrace": a mythical terrace frequented by phoenixes, described in a poem by Li Bai; and an actual hilltop terrace in Chaozhou, Guangdong.

Zhuangzi's bird
A mythical bird akin to the phoenix, called the *yuanchu* 鹓雏, described by the philosopher Zhuangzi in "Autumn Floods."

Li He's phoenix
Alludes to the poem "Li Ping Plays the Konghou" 《李凭箜篌引》 by the Tang poet Li He, in which the exquisite playing of the *konghou* (harp) player is likened to the cry of the phoenix.

Young Jia Yi
A Han Dynasty poet and statesman who failed to realize his ambitions because of an oppressive and rigid bureaucracy.

Half the body of the Tang Dynasty, bodied back to the Six
The Six Dynasties and the late Tang Dynasty both saw great flowerings of Chinese poetry; the elaborate style of the late Tang hearkens back to the style of Six Dynasties poetry.

Geographies scatter, then alight
The word *shanhe* 山河, literally "mountains and rivers" but translated here as "geographies," echoes Du Fu's famous line, "Kingdoms crumble, but mountains and rivers remain."

Master Ying's qin
Alludes to a poem by the Tang poet Han Yu, "Listening to Master Ying Play the Guqin" 《听颖师弹琴》.

How can one who hasn't listened to the phoenix / know whether he has ears? etc.
The two rhetorical questions at the end of this stanza echo other poems by Han Yu.

Guo Moruo
"Phoenix Nirvana" 《凤凰涅磐》, written by the early modern poet and Communist revolutionary Guo Moruo shortly after the May Fourth Movement, is one of the earliest Chinese vernacular poems and is considered a foundational work of modern Chinese poetry.

Wuchang
Site of the Wuchang Uprising, a rebellion that ultimately led to the toppling of the Qing Dynasty and the end of imperial rule.

Tear open the chests / of violence, shred deeds with the weapon's critiques
"Tear open one's chest," *sikai xiongpu* 撕开胸脯, is a phrase that in the language of Communist revolutionaries means to "give it one's all." "The weapon's critiques" echoes the famous phrase of Marx.

Hunter and hunter will look more and more alike
Echoes Bei Dao's poem "Accomplices" 《同谋》: "freedom is just the distance / between the hunter and the hunted."

12

Behold the lone runner . . .
Echoes Ouyang's earlier poem "Athens Shoes" 《去雅典的鞋子》.

13

Ten years ago, it was a TV station. / Thirty years before that, it was just a pair of wheels.
Refers to the Chinese satellite television station, and the classic Chinese bicycle brand, respectively.

14

Chrysanthemum lantern, light of white nights
Alludes to Zhai Yongming's poem "A Chrysanthemum Lantern Is Floating Over Me" 《菊花灯笼漂过来》 and the bar she operates in Chengdu, *Baiye* 白夜 ("White Nights").

Immemorial pain
Echoes Li Bai's poem "Bring in the Wine" (*Jiang Jin Jiu* 《将近酒》): "Together, let us erase our immemorial pain" 与尔同销万古愁.

15

Barry Lam and Lee Shau-kee
Taiwanese computer entrepreneur and Hong Kong real estate tycoon, respectively. Both Lee and Lam were funders of Xu Bing's Phoenix Project, and as of this writing Lam owns the installation.

One minute of the phoenix equals two of the dinosaur
Echoes Ouyang's earlier poem "A Minute Goes By, and the Gods Grow Old" 《一分钟后，天人老矣》.

16

Wangjing
The neighborhood in northeast Beijing where Ouyang lives.

Lu Kuan and Huang Xing
Over the many years it took to see the Phoenix Project to its completion, two children were born to members of the crew working on the installation; their names are Lu Kuan and Huang Xing.

18

Erya
The oldest surviving Chinese dictionary, compiled in the third century BC, which contains one of the earliest references to the phoenix in the Chinese written record.

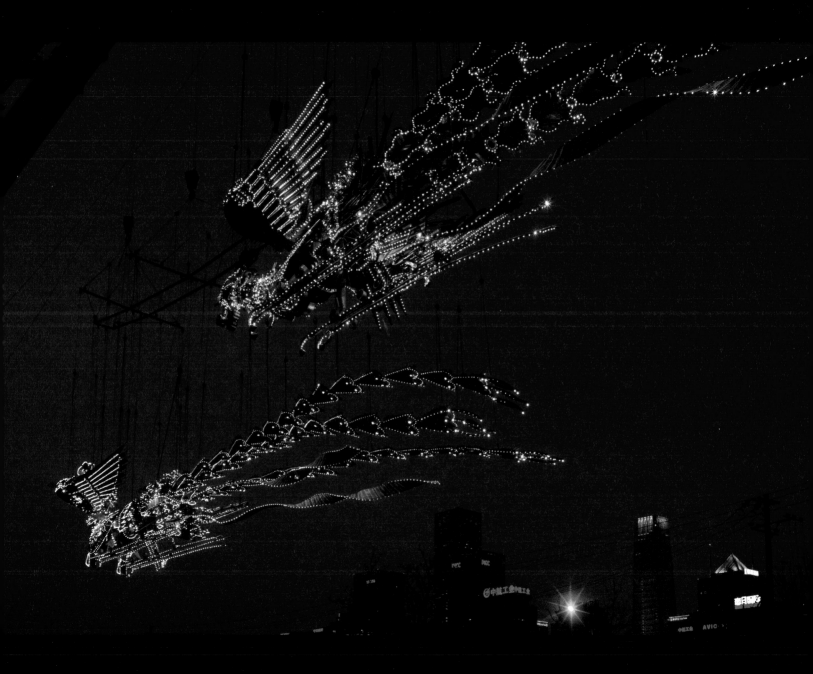

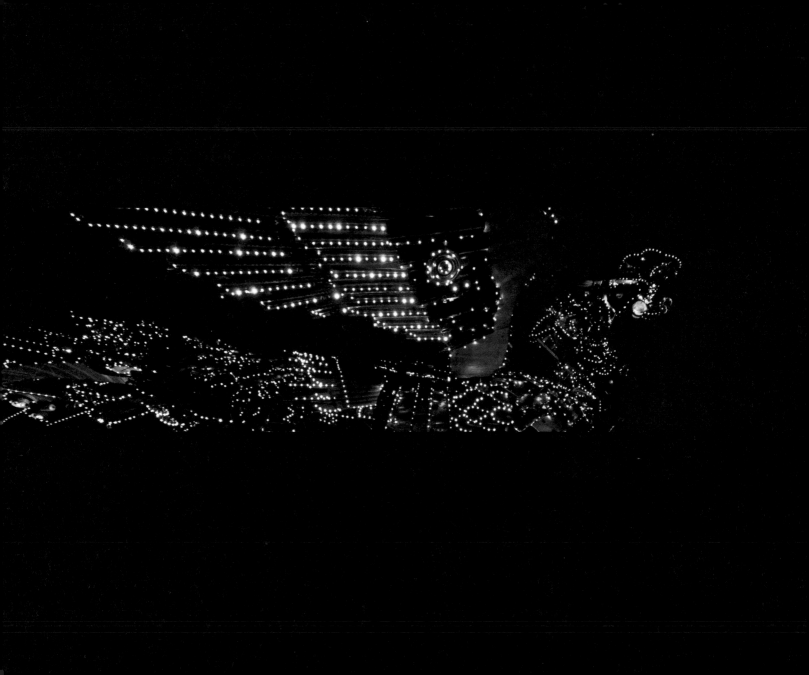

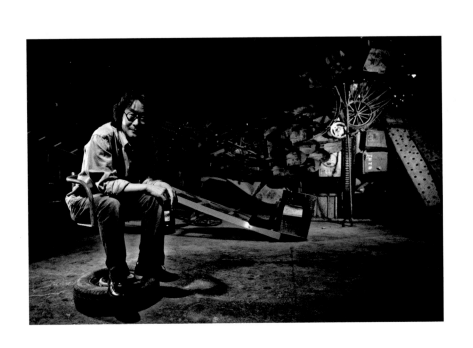

Biographies

Xu Bing 徐冰

Perhaps the best known contemporary Chinese artist, Xu Bing serves as the vice-president of the Central Academy of Fine Arts in Beijing. He is most known for his printmaking skills and installations, as well as his creative artistic use of language.

Ouyang Jianghe 欧阳江河

Known as one of the "Five Masters from Sichuan," Ouyang is one of China's most influential avant-garde poets. His intricate, fugue-like poems are concerned with dissecting the layers of meaning that underlie everyday objects and notions like "doubled shadows." He is also a prominent art critic and calligrapher; he lives in Beijing.

Austin Woerner

A Chinese-English literary translator, Austin Woerner has translated a collection of poetry by Ouyang Jianghe (*Doubled Shadows*) and a novel by Su Wei, and edited the English edition of the Chinese literary magazine *Chutzpah!*. A graduate of Yale and of the New School's creative writing MFA program, he joined Ouyang in 2009 as the first author-translator pair to participate in the Literature in Translation Program at the Vermont Studio Center.

PHOENIX
Poem by Ouyang Jianghe
Poem Translation by Austin Woerner
Sculpture by Xu Bing

Published in 2014 by
Zephyr Press www.zephyrpress.com
MCCM Creations www.mccmcreations.com

Calligraphy by Xu Bing
Book design by typeslowly and MCCM Creations
Printed in Hong Kong

Photographs taken during the construction of the Phoenix in Beijing
and while displayed in Shanghai and at MASS MoCA
(Massachusetts Museum of Contemporary Art)

The publishers acknowledge with gratitude the financial support
of the Massachusetts Cultural Council and the SOMA Project
at City University of Hong Kong.

Zephyr Press, a non-profit arts and education 501(c)(3) organization,
publishes literary titles that foster a deeper understanding of cultures
and languages. Zephyr books are distributed to the trade in the U.S.
and Canada by Consortium Book Sales and Distribution [www.cbsd.com]
and by Small Press Distribution [www.spdbooks.org].

Cataloguing-in publication data is available from the Library of Congress.

ISBN 978-1-938890-0-48 (US)
ISBN 978-988-13114-1-2 (HK)

massculturalcouncil.org

SOMA AT CITYU

香港城市大學
City University of Hong Kong
三 十 周 年 紀 念
專業 創新 胸懷全球